Handmade
Three-Dimensional
Greetings Cards

Dawn Allen

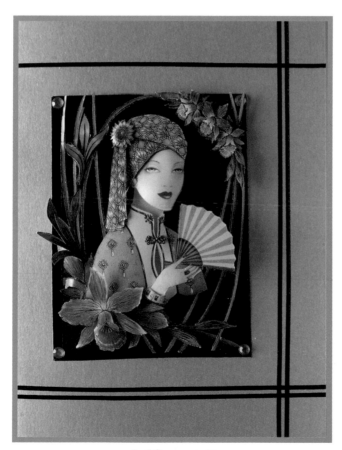

SEARCH PRESS
X000-000-019 2080
ABERDEEN CITY LIBRARIES

First published in Great Britain 2005

Search Press Limited
Wellwood, North Farm Road,
Tunbridge Wells, Kent TN2 3DR

Text copyright © Dawn Allen 2005

Photographs by Roddy Paine Photographic Studios

Photographs and design copyright © Search Press Ltd. 2005

ISBN 1 84448 055 0

The Publishers and author can accept no responsibility for any consequences arising from the information, advice or instructions given in this publication.

Suppliers
If you have difficulty in obtaining any of the materials and equipment mentioned in this book, then please visit the Search Press website for details of suppliers:
www.searchpress.com

Alternatively, you can write to the Publishers at the address above, for a current list of stockists, including firms who operate a mail-order service.

Publishers' note
All the step-by-step photographs in this book feature the author, Dawn Allen, demonstrating how to make three-dimensional greetings cards. No models have been used.

*Dedicated with love to
Ron, Joanne and Robert.*

Manufactured by Universal Graphics Pte Ltd, Singapore
Printed in Malaysia by Times Offset (M) Sdn Bhd

Acknowledgements
A special thank you to Ron for the benefit of his advice and inexhaustible patience. My thanks to Joanne and Anne for their help and encouragement. My appreciation to John Don of Personal Impressions for supplying all the stamping equipment, and to Robin Sudbury of Absolutely Art for his assistance. I could not possibly leave out the team at Search Press for making this book happen – to all of you, a big thank you!

The author and Publishers would like to thank Design Objectives Ltd for allowing them to use the Flower Fairy outline craft sticker on pages 5 and 47; Klein Design, Chesterfield, Derbyshire for the sheets used to make the cards on the cover and on pages 1, 3, 5, 7, 10–13, 14–15, 16–21, 22–23 and 30–34; Manor Art Enterprises Ltd, the publisher of the Morehead prints used on pages 5, 28 and 35 and the Reina prints used on pages 5, 7 and 24–29; Personal Impressions for all of the stamps and stamping equipment used in the book; and Wekabo for the flower print, © Natashja's Atelien, used on page 5, middle top.

Cover
Springtime

Placing the daisies inside the aperture of this pretty card gives the impression that you are seeing them through a window on a fresh spring day. The butterflies' wings are lifted slightly as if in flight, and the butterflies and tags are raised off the surface of the card to accentuate the three-dimensional effect.

Page 1
Elegance

The thin black stripes that frame this beautiful woman are reminiscent of Art Nouveau, and the combination of muted pinks and contrasting black shows how much impact can be achieved through the imaginative use of colour.

Opposite
Abundance of Poppies

These bright red poppies make an eye-catching design, accentuated by the addition of a gold and red stick-on ribbon. The flowers have been glazed, giving them the appearance of fine porcelain.

Contents

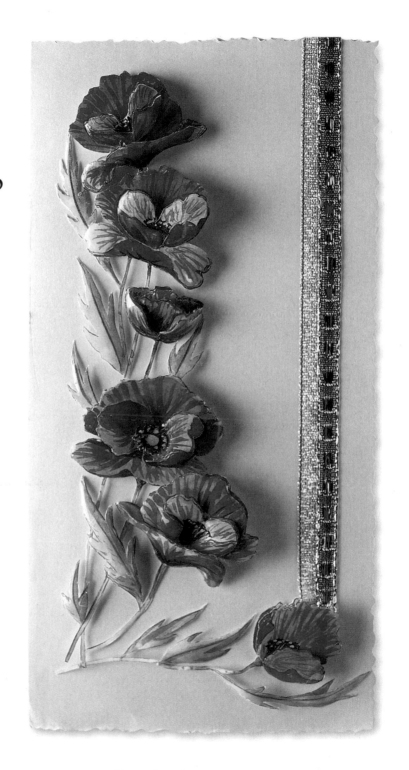

Introduction

Cutting paper to create three-dimensional images started in the nineteenth century, when two identical images were placed on top of each other and separated by a mixture of paste and straw. In the mid- to late twentieth century this was developed into a three-dimensional art form by cutting pieces from several identical prints and layering the cut pieces on to a base image. The spaces between the layers were created using spots of silicone sealant.

Three-dimensional paper decoration has become very popular in recent years with the growing interest in hand-produced cards. Handmade cards are ideal for any occasion, and make a person feel extra special because you have taken the time and trouble to create a beautiful card just for them. In addition, you will have gained a great deal of pleasure from making it! A finished card can, of course, be framed as a permanent keepsake.

Three-dimensional greetings cards can be made from almost any paper image, such as prints, wrapping paper, or designs you have created yourself. You can use as few as four identical images to make a three-dimensional picture, and as many as twenty or thirty can be used to create a truly magnificent sculptured artwork. In general, the more images you use, the more detailed will be the finished picture. Finally, coating the image with a paper glaze will produce an exquisite porcelain effect which not only enhances the colours but also protects your work.

The finished card can be decorated with one or more of the numerous embellishments that are now available, such as glitters, backing papers, buttons, eyelets, charms and ribbons. Craft stickers can be used to add a greeting or sentiment.

Three-dimensional cards are stronger than they look, though they should be protected with a piece of bubble wrap before posting, or you can use a padded envelope or card box if you prefer.

The five projects in this book are each based on a different method for making three-dimensional pictures, and these, together with the various other designs I have included in the book, should equip you with all the technical know-how and inspiration you need to create three-dimensional greetings cards of your own.

I wish you every success and enjoyment with your card making, and always remember that you will never make a mistake – it may be 'just a little bit different', that's all!

4

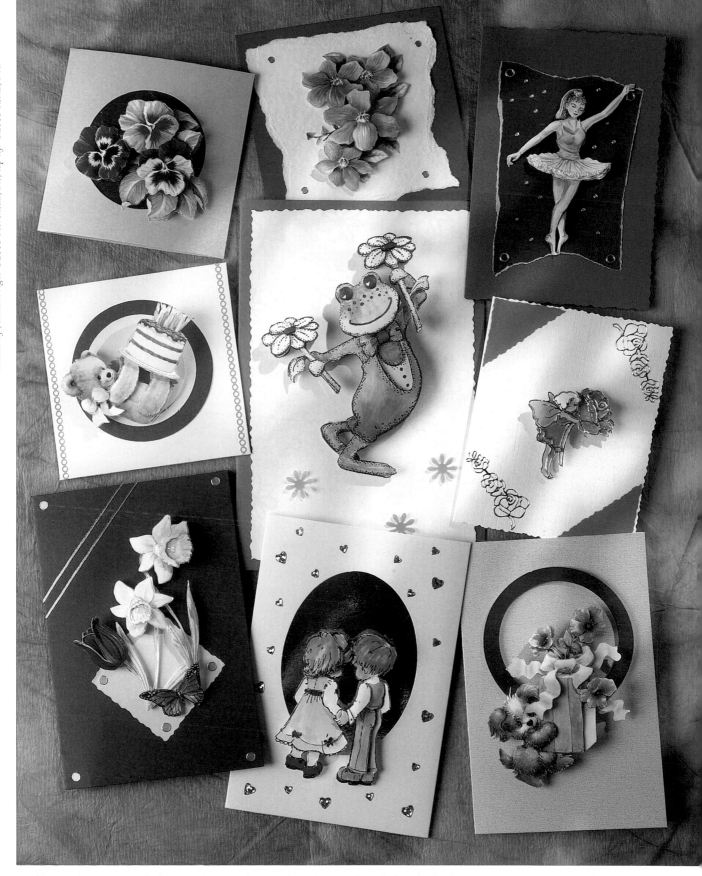

A selection of greetings cards that have been made using the techniques described in this book.

Materials

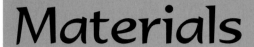

Cards and papers

It is important that you choose the right card on which to mount your three-dimensional picture. If the colours or textures are not quite compatible with your image, the whole look of the card will be spoiled.

Card blanks can be bought in various sizes and colours, with or without apertures or decorative edges, or alternatively you can cut your own card to size from individual sheets, using a rotary paper trimmer. Trimmers are available that allow you to produce your own decorative edges simply by changing the blades. Alternatively you can cut the card to size using a metal ruler and a craft knife.

A gorgeous array of decorative papers and cards is available to use for card inserts, matching envelopes and backing panels (mat mounts). They can also be used to cover the facing page of the inside of a card. Papers come in numerous weights, textures and designs. There are some superb handmade papers, for example mulberry papers, which are made from pulped mulberry leaves. These are very versatile and can be cut and frayed to give a spectacular effect.

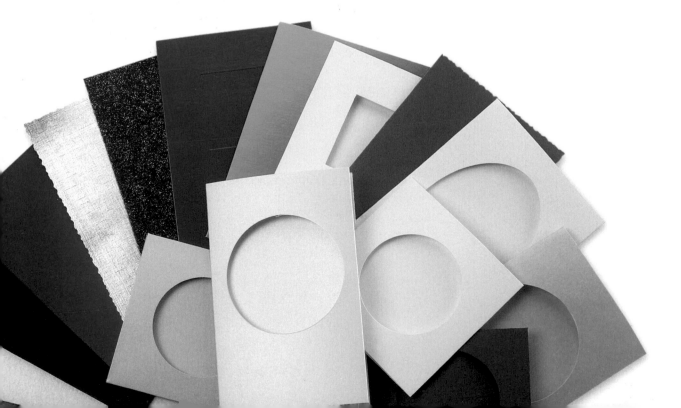

Printed sheets and stamps

You can make a beautiful three-dimensional card from any number of prints, ones you have either created yourself or taken from a pre-printed sheet designed especially for three-dimensional paper crafts. These sheets have four or more identical images on them from which you can select the parts of the finished picture you want to build up to create a three-dimensional effect. Alternatively, you can use one of the numerous step-by-step sheets that you can buy, on which the layered parts of the picture are numbered in the order in which they are to be used.

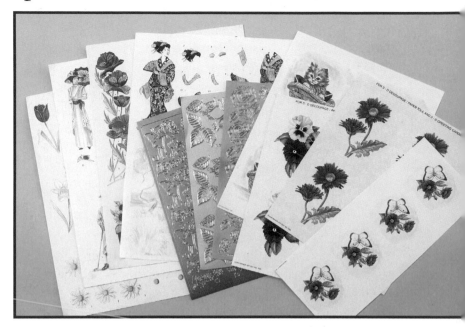

You can also create designs using outline craft stickers, which come in a range of finishes and colours, or stamped images. I like using watercolour pens to add colour because they are so easy to use and you can produce gorgeous effects by blending colours together and adding water to make them lighter, but the type of paint, pen or crayon you use is really down to personal choice. Experiment with different media and see what amazing finishes you can produce!

If you decide to invest in a set of watercolour pens, it is also worth purchasing a blender pen. Mix colours on a sheet of acetate, then use the blender pen to pick up the colours and apply them to your picture. This gives a softer effect than applying the pens directly to the card.

If you are using rubber stamps, make sure you use a solvent-based inkpad as this type of ink will not bleed when you apply colour to the image, and for the best results stamp on to medium-weight card. This weight of card works well with moulded or shaped cut pieces.

7

Embellishments

There is such a good range of paper embellishments available today that you can really let your imagination run wild! Add stick-on ribbons, multicoloured feathers, decorative papers, glitter, sequins and tiny beads to make your card extra special. Use craft stickers to decorate your card or to add a simple greeting such as 'happy birthday' or 'good luck'.

Take care when choosing which embellishments to add to a card – they should be used to enhance the design and not detract from it. Use colours, styles and textures that work together to create a coherent look, and do not fall into the trap of over-decorating your card. Use embellishments sparingly and thoughtfully, and don't be afraid to add no extra decoration at all if the card works well without it.

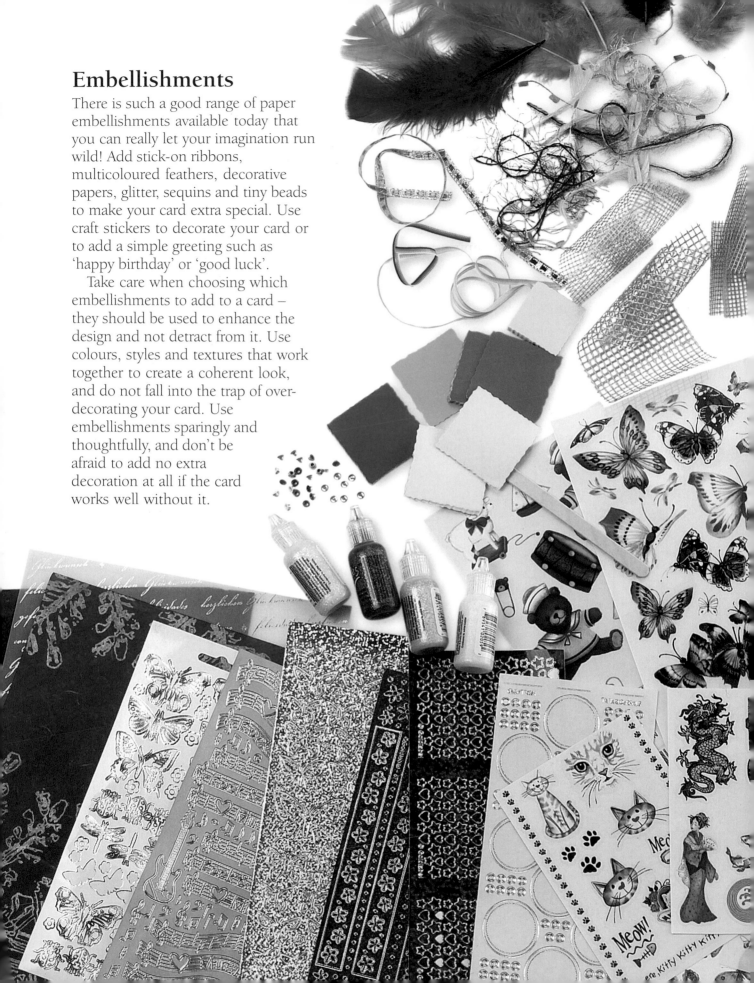

Other equipment

To cut out your images, you will need either a small pair of **sharp-pointed scissors**, or a **craft knife** that can take a standard size 10A blade. Always make sure you have a good supply of **spare blades**. A **steel ruler** is useful for achieving straight edges. The best surface for cutting on is a self-healing **cutting mat**, which 'heals itself' after a fine cut (see page 10). For rubber stamping, a **stamping mat** is also very useful, though not essential.

For shaping your cut-out pieces you will need a round-ended, a pointed, a flat-ended and a spoon-shaped **wooden shaping tool**. Use them in conjunction with a **pencil eraser** for hard shaping, or a **foam pad** (the sort used for applying make-up) for soft shaping (see page 13).

For attaching the various layers of the image, I use either **silicone sealant** or **3D foam squares**. Silicone sealant sets hard and can be applied as raised spots of glue to create depth between the layers. 3D foam squares have the same effect but are less flexible (see page 14).

Tweezers, both long and angled, are useful for manipulating small cut-out pieces and for manoeuvring them into position. **Cocktail sticks** can also be used to position cut-out pieces, and to apply the silicone sealant.

If you wish to glaze your image, you will need a **paintbrush** and **brush cleaner**.

Fancy-edged scissors are useful for adding a decorative edge to your card or backing paper. **Rotary paper trimmers** achieve very much the same result as scissors, and come with different patterned **cutting wheels**. Alternatively, a **paper guillotine** allows you to produce perfectly straight edges.

Use either **double-sided tape** or **adhesive dots** (available on a continuous roll in a refillable dispenser) to attach pieces of decorative card or paper to your greetings card, and to attach your finished three-dimensional image. Adhesive dots are especially useful as they are available in both repositionable and permanent form.

Finally, if you decide to decorate your cards using **eyelets**, a **mechanical eyelet tool** is an excellent way of fixing them in place.

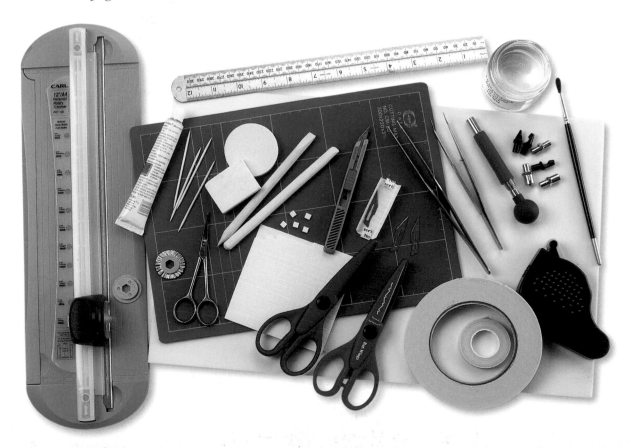

Basic techniques

There are several different methods of making three-dimensional cards. I am going to explain how to use pre-printed sheets, step-by-step sheets, outline craft stickers and rubber stamps. All the materials used in these projects can be obtained through good craft outlets.

Before starting on the projects it is a good idea to practise the basic techniques used in cutting, shaping and mounting.

Cutting using a craft knife

There are two methods of cutting: using either a pair of sharp-pointed scissors or a craft knife. It can be difficult to cut fine, intricate shapes with scissors, whereas if you learn to cut correctly with a craft knife you can achieve much greater precision, and the finished product looks far better. You will need a knife that is capable of taking a standard size 10A blade, which is flexible and which has a very sharp cutting point.

The basic technique for cutting using a craft knife is very simple. If you pick up a pencil and start to write or draw, you will notice that you are holding the pencil at a slight angle –hold your knife in exactly the same way.

You will need a board to cut on. Do not use a chopping board, bread board or anything with a hard surface as this will only blunt the blade and leave raised edges under your work which will make cutting difficult. The best surface is a self-healing cutting mat which, as the name implies, seals itself after a fine cut and therefore retains a smooth, flat surface.

Tip
Always use a sharp blade in your craft knife – a blunt one may tear the paper. You will achieve far better results if you always start a project with a new blade.

1. When you begin cutting, relax, hold the knife comfortably at an angle of about 30° to the cutting surface and cut gently in a flowing movement around the outline of the shape. In this way you are effectively bevelling the paper by cutting away the underneath part so that the white edge of the paper will not be visible.

2. Start at the top and work down the right-hand side of the piece to be cut. Turn the paper as you cut, following the outline.

3. Keep the knife on the right-hand side of the cut so the cutting line is always visible. There is no need to press too hard.

Tip
Reverse Step 3 if you are left-handed.

Furring and feathering

You can use either a craft knife or scissors to create the effect of fur or feathers, though a knife will always give you a finer finish – you do not want your animal to end up looking as though it needs grooming!

To achieve this effect successfully, the angle of your knife or scissors is important.

1. Angle the knife from side to side, making a criss-cross pattern.

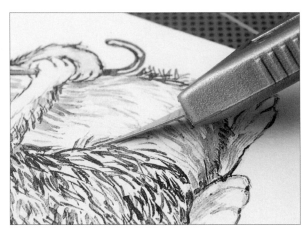

2. Lengthen and shorten the cuts as necessary to obtain a fur-like effect.

Tip

With this technique it is sometimes necessary to colour in the edge. Do this using watercolour pens/pencils. Always use a shade lighter than the actual image, and colour from the back to hide any white edges.

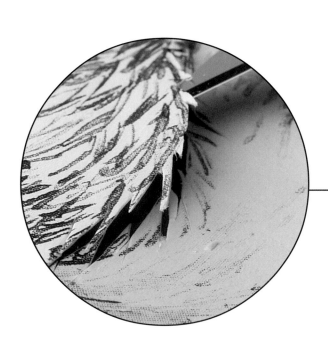

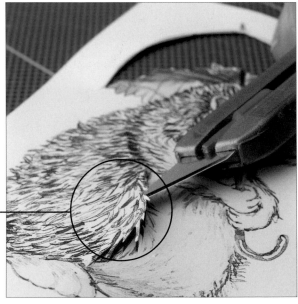

3. The closer you make the cuts, the finer the furring/feathering will be.

Shaping

Shaping is an essential part of three-dimensional picture sculpture. To achieve natural-looking shapes you need to visualise the subject in real life and then re-create it in three dimensions. Use wooden shaping tools in conjunction with a small foam pad or an eraser to avoid creasing or tearing the piece you are shaping.

Only the top pieces of the image (the pieces that are not covered by another piece) need to be shaped. To achieve the required shape, place the cut piece face down on either an eraser or a foam pad and gently roll it into the required shape using the shaped end of a shaping tool.

Be gentle and keep the shaping slight; if you over-shape the piece it will not fit completely over the piece behind it. When you have achieved the desired result, hold the piece in position with tweezers to see if the shape is correct. If it is, then apply; if not then re-shape it and try again.

You will need
Wooden shaping tools
Pencil eraser
Foam pad

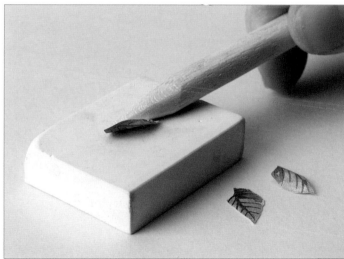

For a firm, rounded shape such as leaves or berries, apply hard shaping using a pencil eraser and a pointed shaping tool.

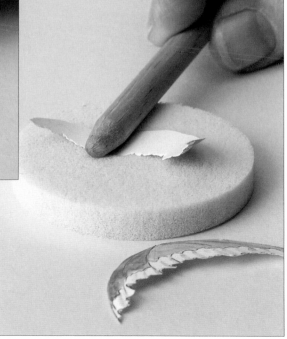

For softer curves, apply soft shaping using a foam pad and a rounded shaping tool.

Mounting

There are two methods of mounting the pieces: using either 3D foam squares or silicone sealant.

Sealant will give a better result, as you can control the height and width of the sealant by applying it to your work using a cocktail stick. Use approximately 3–5mm (¼in) of silicone between the base print and the first layer, and approximately 2–3mm (⅛in) between subsequent layers. If you can, leave the first layer to dry for five to ten minutes. By leaving this piece to cure it makes it easier to apply the rest of the pieces.

You will need
Silicone sealant
3mm (⅛in) 3D foam squares
Cocktail sticks for applying the silicone sealant
Angled and straight tweezers
Craft knife

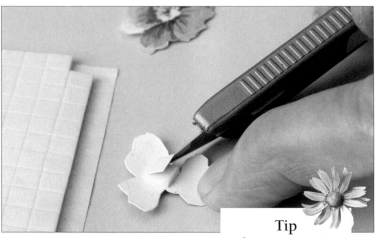

If you are using 3D foam squares, apply a square to the back of the piece, and gently lift off the backing using the tip of a craft knife.

Tip
If you are using 3D foam squares, put two squares together to obtain extra height.

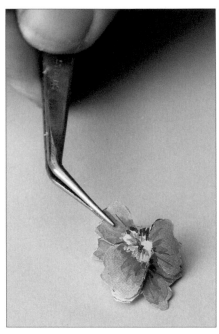

Once you have applied either silicone sealant or foam squares to your cut-out piece, use tweezers to place the piece on your image and if necessary use a clean cocktail stick for fine adjustments. If you have used silicone sealant, do not use your fingers to push the piece down on to the work as it will flatten and spread the glue over the edges; use a cocktail stick.

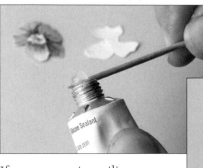

If you are using silicone sealant, transfer the required amount of sealant on to a cocktail stick.

Apply it to your work using a rolling motion.

Tip
Keep the silicone away from the edges of the print to avoid it being seen on the finished card.

Glazing

Glazing can certainly enhance a card by creating a porcelain effect, but it is really a matter of personal preference. It is not always necessary to glaze the whole card; select the parts that you feel would be accentuated by glazing. Remember always to test a scrap piece of your work first to make sure it is colourfast.

It is necessary to apply only a single coat of glaze. Allow three to four hours for the glaze to dry, and remember to clean your brush immediately after use using a spirit-based brush cleaner.

You will need
High-gloss paper glaze
Camel hair paintbrush
Spirit-based brush cleaner

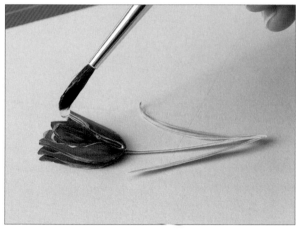

1. Load the paintbrush with glaze, transfer it to the image and allow the glaze to drop on to the image from a height of about 0.5cm (¼in).

Caution
To use high-gloss paper glaze safely, use it only in a well-ventilated area, avoid breathing in the fumes directly, and keep the glaze well away from naked flames. Children must not be allowed to use paper glaze unsupervised.

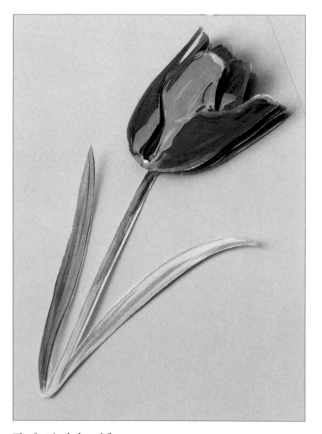

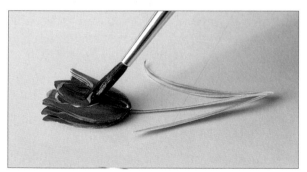

2. Pull the glaze down the image with the brush. Repeat until the glazing is complete.

The finished glazed flower.

Oriental Beauty

For this card I used a step-by-step sheet. These sheets are an excellent introduction to three-dimensional paper craft, as you simply need to cut round the numbered pieces and mount them in numerical order. It is best to cut out everything first before attempting to assemble the card.

Oriental designs have always been popular, and this card's bold, joyful colours coupled with the Japanese greeting of goodwill make it ideal for any celebration.

You will need

Step-by-step sheet (Klein Design 127)

Red A5 card blank, 148 x 210mm (6 x 8¼in)

Blue card, 130 x 180mm (5 x 7in)

Japanese greeting craft sticker

Permanent adhesive dots or double-sided tape

Silicone sealant

Tweezers, straight and angled

Cocktail sticks

3mm (⅛in) 3D foam squares

Craft knife and spare blades

Cutting mat

Fancy-edged scissors

Shaping tools

Eraser

Foam pad

Pencil

Steel ruler

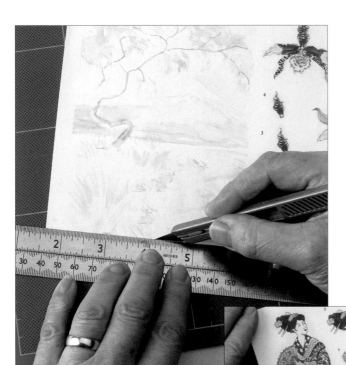

1. Begin by cutting out the background scene using a steel ruler and a craft knife.

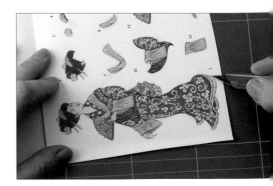

2. Cut out the complete figure using the technique described on pages 10–11. This is the base on which the three-dimensional image will be built up.

3. As you work around the figure, move the paper to achieve the correct position for cutting.

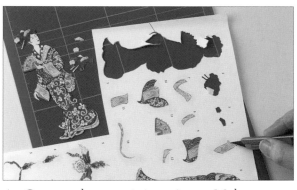

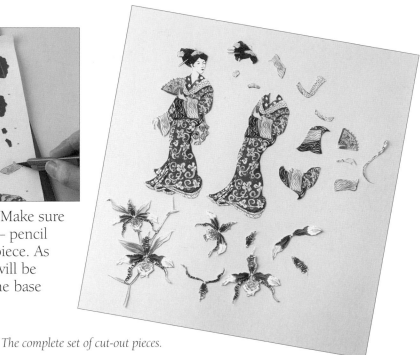

4. Cut out the remaining pieces. Make sure you keep them in the right order – pencil the number on the back of each piece. As with all step-by-step sheets, you will be attaching the cut-out shapes to the base figure in numerical order.

The complete set of cut-out pieces.

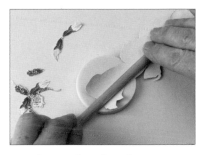

5. Shape the head of the base figure by placing it face down on an eraser and rubbing it firmly with the back of the spoon-shaped shaping tool.

6. Shape the skirt by resting it on the foam pad and gently rolling the shaping tool backwards and forwards over it.

7. Shape the cut-out hair using the same technique as you used for the head.

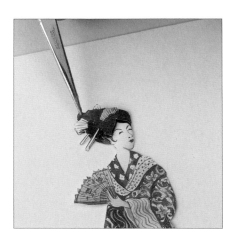

9. Pick up the cut-out hair using straight tweezers and position it over the hair on the base figure.

8. Apply silicone sealant to the back of the hair using a cocktail stick.

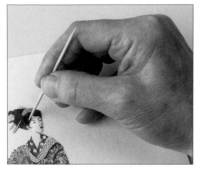

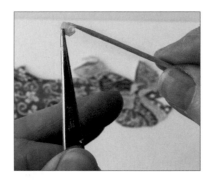

10. Manoeuvre the cut-out hair into position using a cocktail stick.

11. Apply silicone sealant to the next shape in the sequence (the hair comb). Because it is so small, you will find it easier to hold the shape using the tweezers.

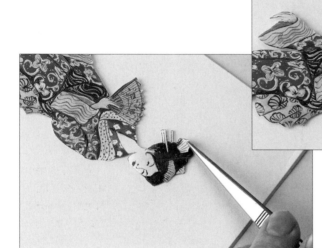

12. Position the comb on the hair of the base figure. Position the second hair comb in the same way.

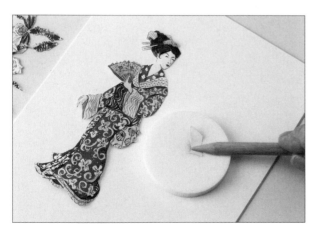

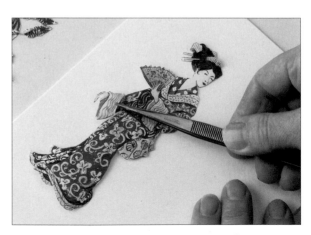

13. Gently shape the next piece in the sequence – the left-hand cuff – using the pointed shaping tool. Shape the edges only, leaving the middle part flat.

14. Glue the cuff into position on the base figure using silicone sealant.

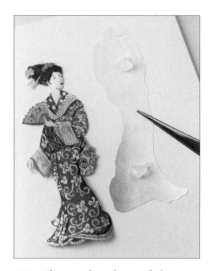

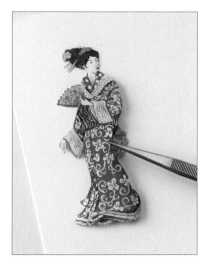

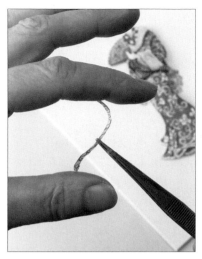

15. Shape the skirt of the cut-out dress in the same way as in Step 6. Apply a spot of silicone sealant to each end of the piece. Do not spread it out.

16. Apply the dress to the base figure. The two spots of silicone sealant raise the cut-out piece above the background, producing a three-dimensional effect. Allow fifteen minutes for the silicone sealant to dry before moving on to the next step.

17. Continue to shape and apply the cut-out pieces to the base figure. Shape the rim of the dress (shown in the photograph) by holding it in the tweezers and gently bending the ends downwards with your fingers. Apply a small spot of silicone sealant to each end, wipe away any excess with your fingers, and apply it to the base figure.

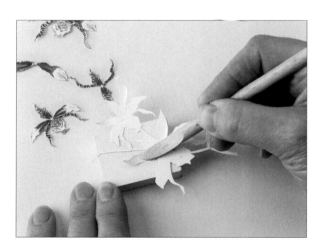

18. Now construct the flowers. Begin by shaping the base flower using hard shaping. Rest it on an eraser and rub it firmly with the spoon-shaped shaping tool.

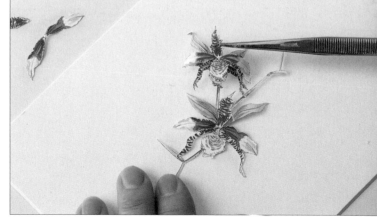

19. Shape the next flower piece in the same way, apply a spot of silicone sealant to its centre and attach it to the base flower. Shape and apply the rest of the pieces.

The completed three-dimensional pictures. Leave them to dry completely before constructing the card. This should take approximately two hours.

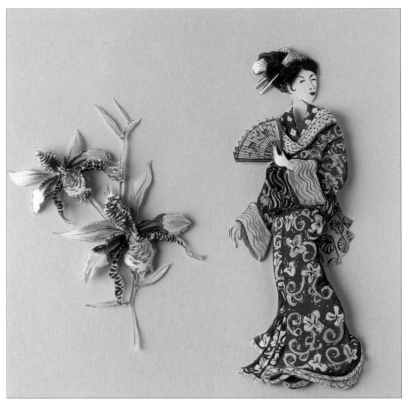

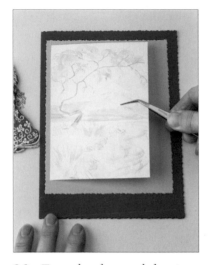

20. To make the card, begin by giving a decorative edge to the card blank and the blue card, then attach the mat mount to the front of the greetings card. Attach the background scene to the mount, allowing enough room in the right-hand margin for the Japanese greeting.

Tip
To fix the mat mount into position, use double-sided tape or permanent adhesive dots.

21. Apply 3D foam squares to the back of the figure.

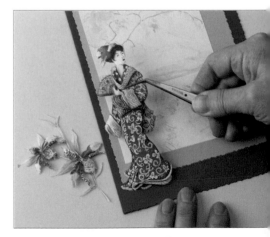

22. Attach the figure to the card. Complete the card by attaching the flower and the Japanese greeting craft sticker.

20

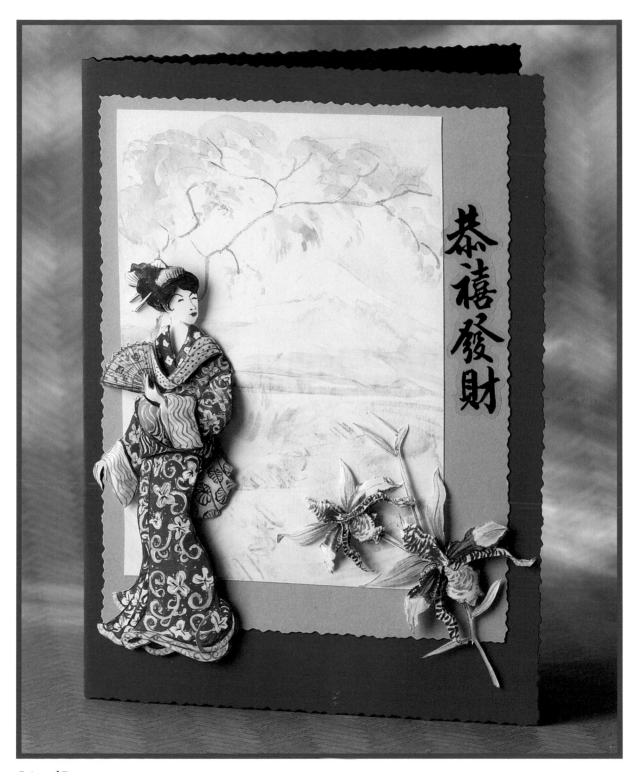

Oriental Beauty

I particularly like this card because of its sense of peace and tranquillity. The blue in the woman's dress is reflected in the blue mat mount and the peaceful background scene. This combination of red, blue and yellow is typical of oriental designs.

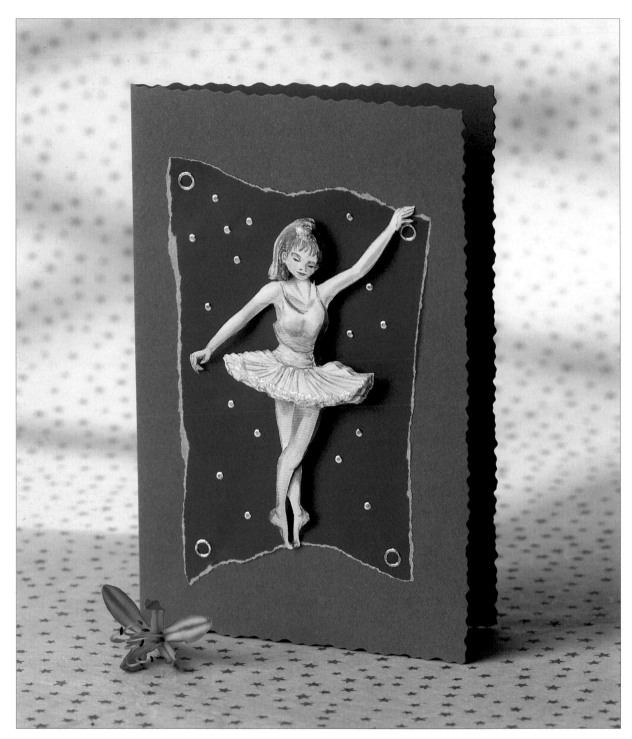

Snow Dance

This dainty little ballerina is mounted on a piece of thin purple paper with a delicately torn edge. The background has been decorated with tiny silver stick-on dots and rings which lend a magical, wintery feel to the design. A lovely card for a young girl with a Christmas birthday, perhaps.

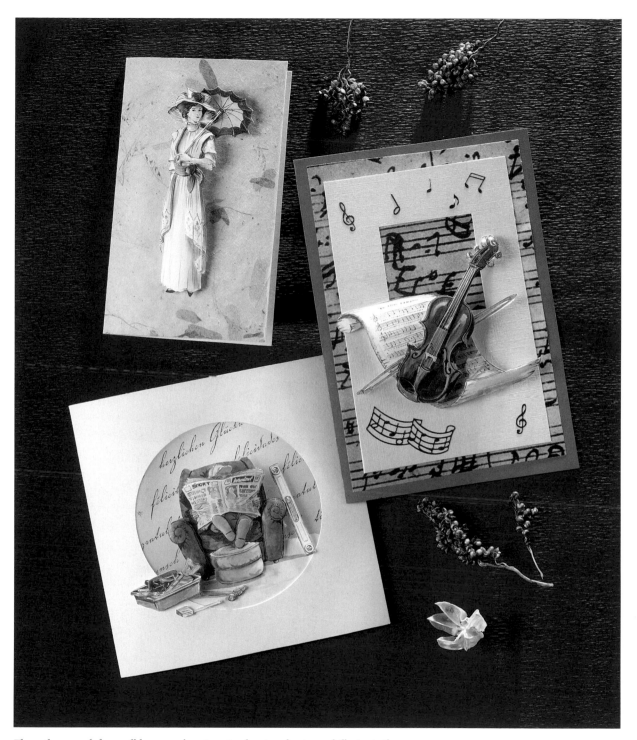

These three cards have all been made using step-by-step sheets, and illustrate the range of designs available. Backing papers, cards and embellishments have been used to reinforce the cards' themes. In the bottom left-hand card, most of the three-dimensional picture is within the aperture, but some elements lie partly outside it. This is an effective way of giving added depth to a three-dimensional image.

Purple Pansies

Using identical images rather than step-by-step sheets to create a three-dimensional card gives you the chance to be really creative! You can put in as much or as little detail as you wish simply by varying the number of pieces you cut out – the more pieces you use, the more detailed your design will be. You can also, of course, use as many copies of the image as you need.

Begin by visualising the finished card, and decide which parts of the image you want to stand out from the background. Look at the details – layering the tiny dewdrop on this bunch of pansies really made it stand out and enhanced the beauty of the whole card. The next step is to plan how you will cut out your pieces. Always start with the layers at the back of the picture and work your way forwards.

All this takes time, but it is well worth the effort when you see the end result and know that it is all your own work!

You will need

Pre-printed sheet
(Pansies III by Reina)

Dark purple A6 card blank,
105 x 148mm (4¼ x 6in)

Light purple card,
80 x 120mm (3¼ x 4¾in)

Cream card, 90 x 130mm
(3½ x 5in)

Small gold circle craft stickers

Permanent adhesive dots or
double-sided tape

Silicone sealant

Tweezers, straight and angled

Cocktail sticks

Craft knife and spare blades

Cutting mat

Fancy-edged scissors

Shaping tools

Eraser

Foam pad

1. Cut out one complete image from the sheet using the cutting technique described on pages 10–11. Cut approximately 2mm (¹/₈in) out from the edge of the image to create a light border when the image is attached to the card. This will form your base print.

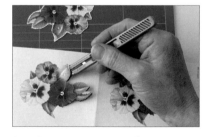

2. Cut out a second complete image, this time cutting close to the edge.

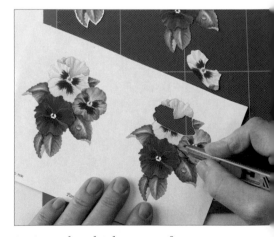

3. Decide which parts of your picture you want to stand out, and cut these out from the remaining two images on the sheet. Begin with the parts that are at the back of the picture, and gradually move forwards to those that are at the front.

©2005, Reina, N.Y.

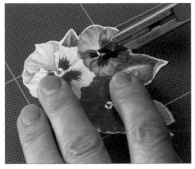

4. Cut pieces from the base print if you need to, as this will be covered up by the top layers of the image.

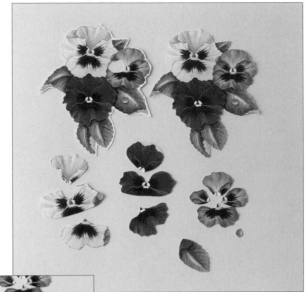

The complete set of cut-out shapes ready for making into the three-dimensional image.

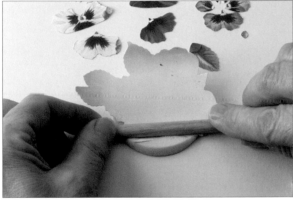

5. Softly shape the edges of the leaves on the second complete image you cut out using the barrel of a shaping tool.

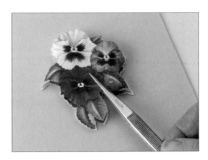

6. Make sure you have not made the image too small through over-shaping by holding it over the base print. (You can make the image flatter by gently flicking back the sides.)

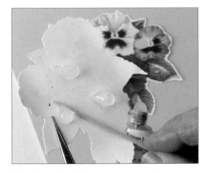

7. Apply three spots of silicone sealant to the back of the image and attach it to the base.

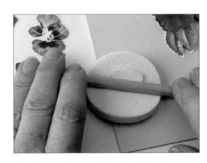

8. Starting with the back flower, gently shape each petal by rolling the shaping tool over the base (but not the outer part) of the petal.

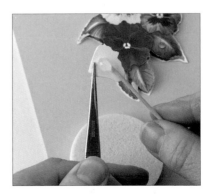

9. Place a spot of silicone sealant in the centre of the petal.

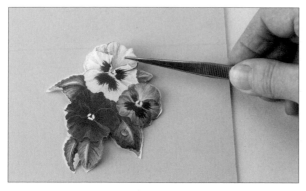

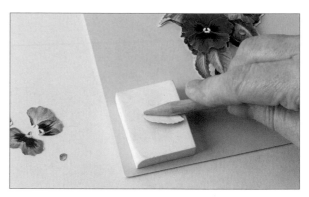

10. Attach the petal to the base flower. Tilt it gently towards the centre of the flower, raising up the outer edge, to give a three-dimensional effect. Apply the remaining petals to the back flower in the same way. Allow the silicone sealant to dry.

11. Shape the leaf gently using the eraser and the pointed shaping tool. Roll it on the diagonal to give a pleasing shape to the leaf.

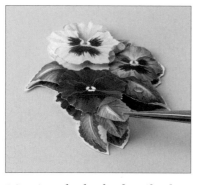

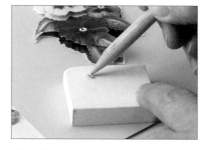

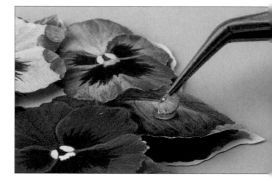

12. Attach the leaf to the base using a single spot of silicone sealant.

13. Shape the dewdrop on the eraser using the pointed shaping tool. Use circular movements to give the dewdrop a smooth, rounded shape.

14. Apply a tiny spot of silicone sealant to the back of the dewdrop and, using the angled tweezers, carefully lay it in position on the base print.

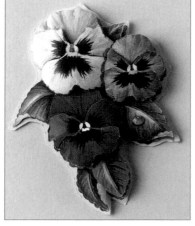

16. Prepare the card, attaching the mounts using either permanent adhesive dots or double-sided tape, and attach the three-dimensional image using silicone sealant. Finish by adding a small gold circle to each corner of the purple mount.

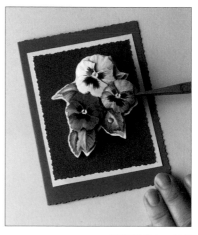

15. Build up the remaining parts of the image in the same way.

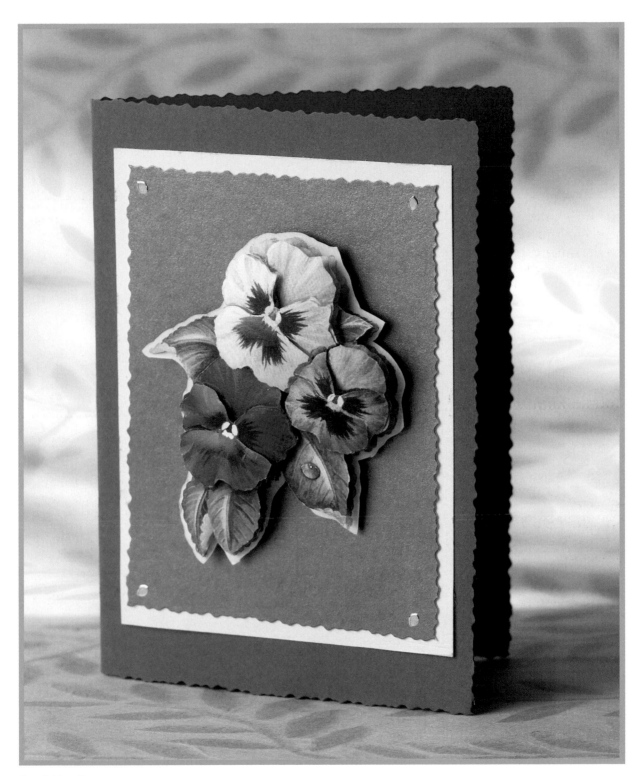

Purple Pansies

The cream-coloured border around the pansies was very easy to achieve and gives
this card a much lighter feel. It is accentuated by the cream border around the
purple mat mount, and the addition of details like the raised dewdrop and the tiny
gold circles at each corner of the background.

©2005, Reina, N.Y.

27

Flowers have always been a popular subject for greetings cards. All of these were made from pre-printed sheets, and they show how various types of card blanks and embellishments can be used to enhance, but not detract from, the intrinsic beauty of the three-dimensional image.

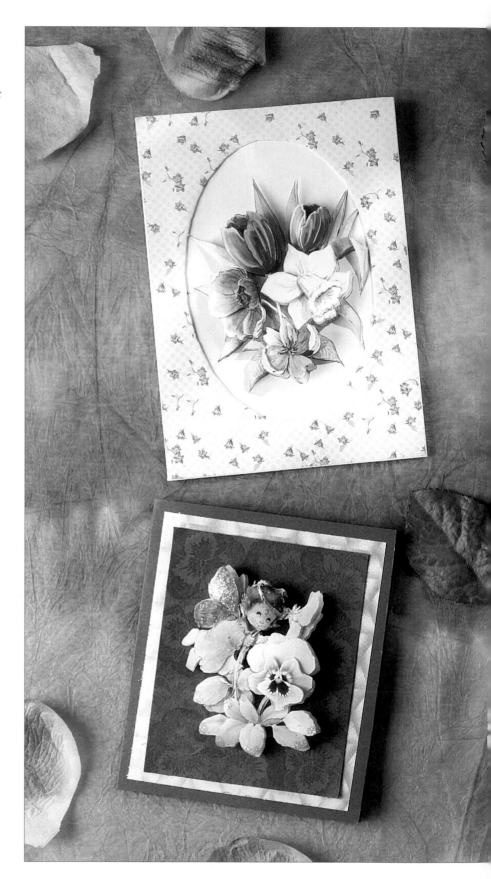

Top row and bottom right ©2005 Reina, N.Y.; bottom left ©2005 Morehead, Inc.

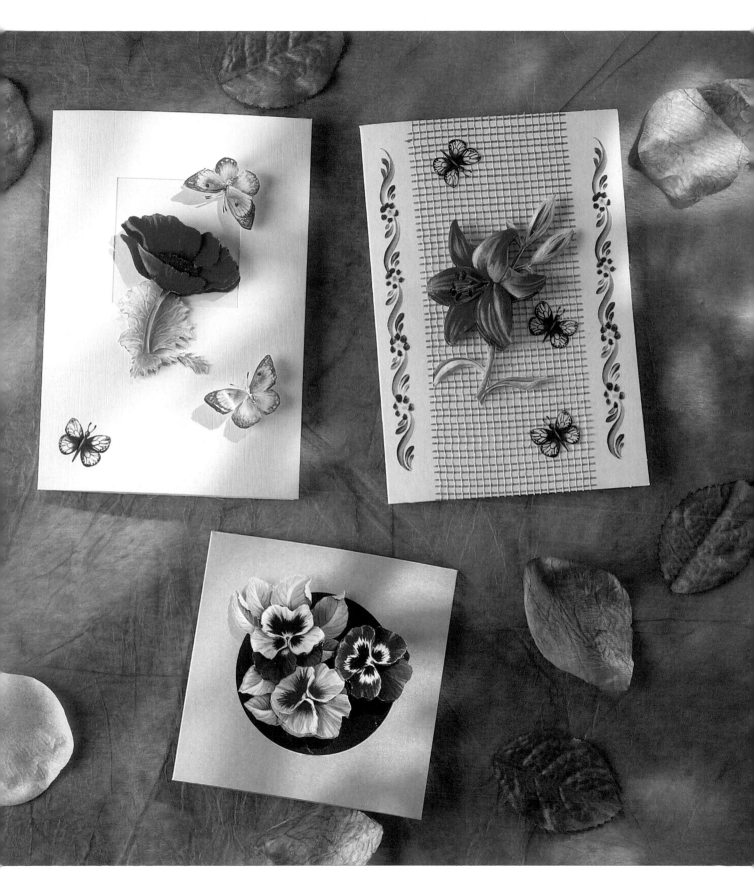

Cute Kitten

No-one can resist a cute kitten or puppy, and most people will be delighted to receive this lovely card. You can make the cat's fur look very realistic by a simple cutting technique known as 'furring' (see page 12). This technique does require some practice, but once achieved it can be used to give a highly realistic finish to animal fur, bird feathers, hair, grass and so on.

Practise on scrap pieces of pictures first, and always have a new blade in your knife – a blunt blade may tear the paper.

You will need

Pre-printed sheet
(Klein Design 105)

Pink A6 card blank,
105 x 148mm (4¼ x 6in),
with 75mm (3in) circular
aperture

Paw-shaped craft stickers

Permanent and repositionable
adhesive dots or
double-sided tape

Silicone sealant

Tweezers, straight and angled

Cocktail sticks

Craft knife and spare blades

Cutting mat

Shaping tools

Eraser

Foam pad

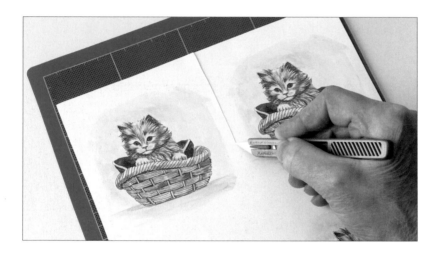

1. Cut round the first image on the sheet and use this as your base print.

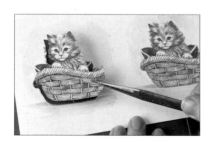

2. Cut out the head, body and basket from the second image. Cut neatly round the fur on the head – there is no need to use the furring technique at this stage as it will be covered by another layer.

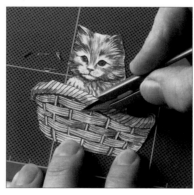

3. Cut some of the black pieces out of the basket. This helps to give it a three-dimensional look.

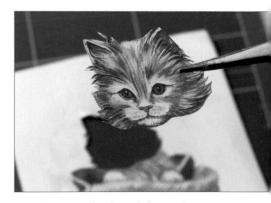

4. Cut out the head from the third image. Use the technique described on page 12 to cut round the fur.

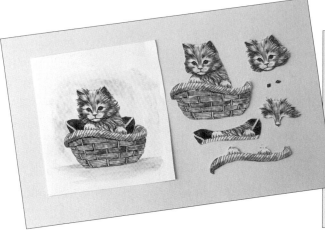
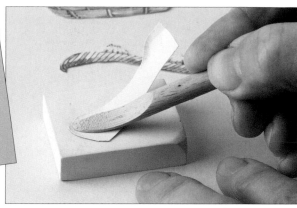

5. Cut out the cushion, cutting into the rim of the basket, from the rest of the third image. Cut the mask, the eyes and the rim of the basket with the cat's paws attached from the final image. You are now ready to start assembling your three-dimensional picture.

6. Give the pillow a rounded appearance by resting it on the eraser and shaping the corners using the spoon-shaped shaping tool.

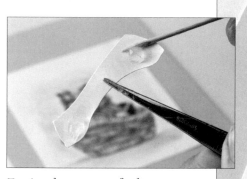
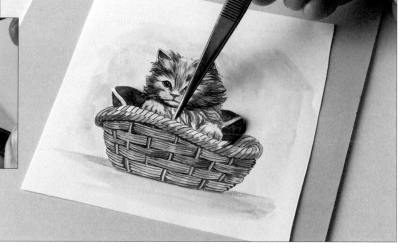

7. Apply a spot of silicone sealant to each corner of the pillow.

8. Attach the pillow to the base print using the straight tweezers.

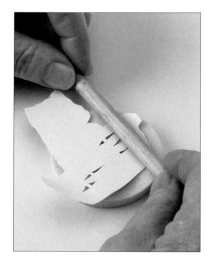
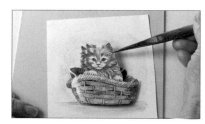

9. Shape the sides of the basket by gently rolling them backwards and forwards with a shaping tool on the foam pad.

10. Apply silicone sealant as close as possible to the edges of the basket and attach the cut-out image to the base.

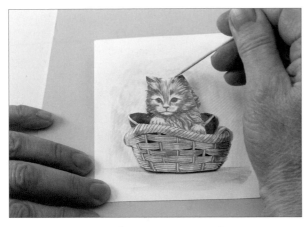

11. Manoeuvre the image into place using a cocktail stick.

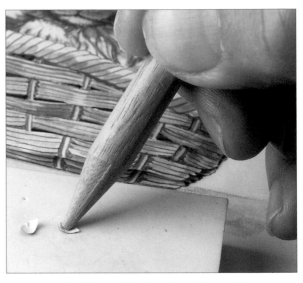

12. Gently shape the head and attach it to the base, then use small, circular movements to give the eyes a rounded shape using the pointed shaping tool.

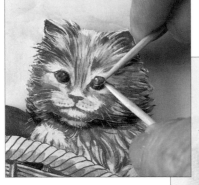

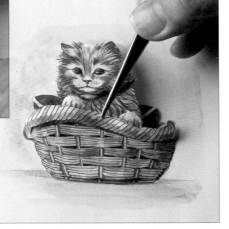

13. Apply a tiny spot of silicone sealant to each eye and manoeuvre them into position using two cocktail sticks.

14. Shape the edges of the rim of the basket, and shape the paws using the round-ended shaping tool. Put a small spot of silicone sealant on each paw, and at each end of the basket rim, and apply the pieces to the base.

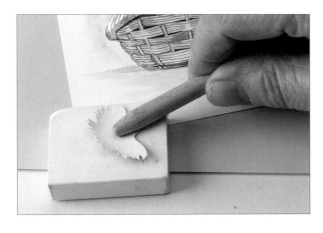

15. Use the spoon-shaped shaping tool on the eraser to shape the mask. Give the top of the head a smooth, rounded shape, then rub firmly up and down on the nose with the round-ended shaping tool to curve it round.

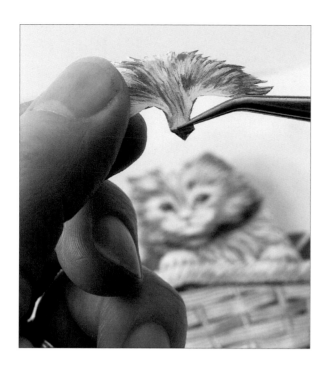

16. Bend the end of the nose down using a pair of angled tweezers and attach the mask to the image. The three-dimensional picture is now complete.

The completed three-dimensional image.

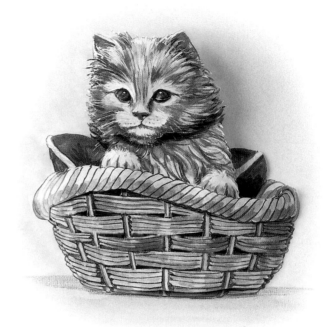

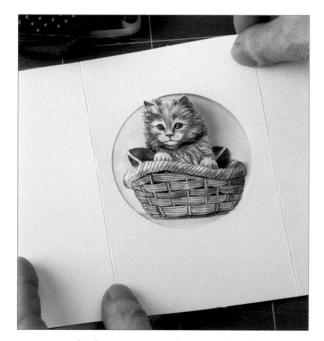

17. Attach the image to the inside of the aperture card using repositionable adhesive dots or double-sided tape. Cut down the image to fit if necessary.

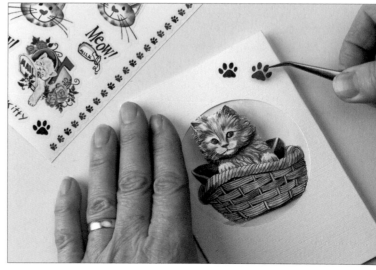

18. Fold the inside flap over the back of the image and glue it in place. Decorate the front of your card with the craft stickers.

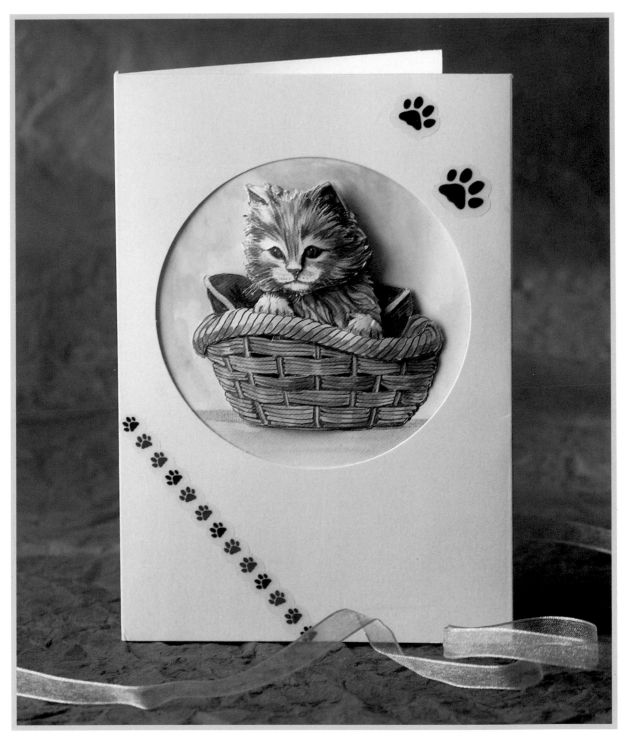

Cute Kitten

This appealing little card is made even more so by the rather forlorn expression on the kitten's face! Animal lovers of all ages will adore it, and it is very easy to make. The three-dimensional effect has been accentuated by cutting out some of the spaces in the woven basket, and embellishments in the form of paw-shaped craft stickers emphasise the animal theme.

Cute cards like these are popular with all age groups. The images in the two left-hand cards have been placed in front of circular mounts that enhance the three-dimensional effect and emphasise their childlike quality.

A Gift for You

You will need

Rubber stamp
(Fun Stamps F-M119 Gift
Mouse)

Solvent-based inkpad

Medium-weight white A4 card

Stamping mat

Watercolour pens, blender and
sheet of acetate for mixing colours

Cream A6 card blank,
105 x 148mm (4¼ x 6in), with
50mm (2in) square aperture

Pink card

Small red heart craft stickers

Permanent and repositionable
adhesive dots or
double-sided tape

Cutting mat

Craft knife and spare blades

Scissors

Silicone sealant

Cocktail sticks

Tweezers, straight and angled

Shaping tools

Foam pad

Eraser

Using rubber stamps is a highly creative, versatile way to make three-dimensional cards. You can use the same stamp to make a wide variety of different cards simply by varying the colours and types of inks, pens and so on, and you can make as many images as you need. It is particularly satisfying if you enjoy colouring or painting. For this project I used watercolour pens, which give the same effect as watercolour paints but are easier to control.

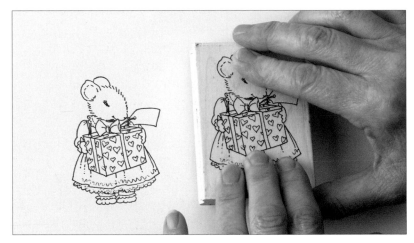

1. Resting your work on a stamping mat, stamp five images on to the piece of white A4 card.

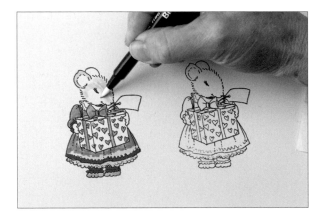

2. Using watercolour pens, apply colour to each of the images. Start with the lightest shades and end with the darkest. For the mouse's fur, apply the paint with a blender for a lighter, less solid appearance.

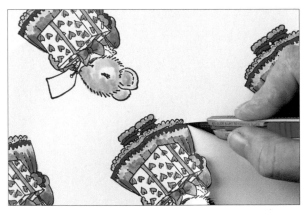

3. Cut out the shapes you need from your five images. Remember to cut out your base print first, and to work from the back of the picture to the front. The cut-out shapes I have used are shown at the top of the next page.

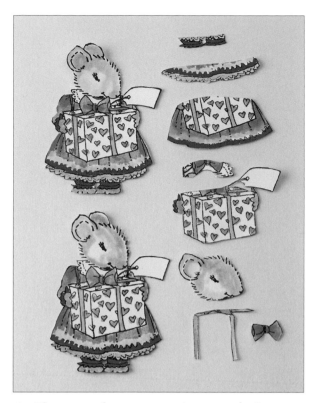

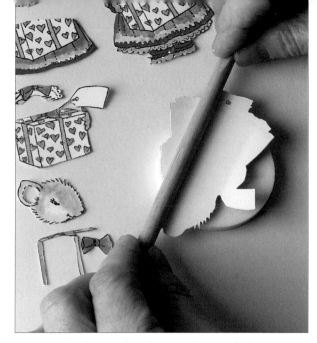

4. These are the cut-out pieces ready for assembly. Use the technique described on page 12 to cut round the mouse's fur. When you cut out the head, take out the middle of the left-hand ear.

5. Gently shape the dress of one of the complete images by resting it on a foam pad and rolling backwards and forwards over it with a shaping tool.

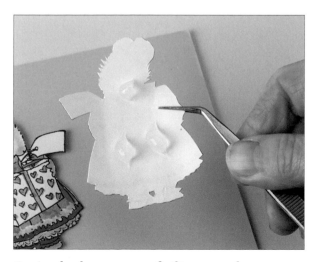

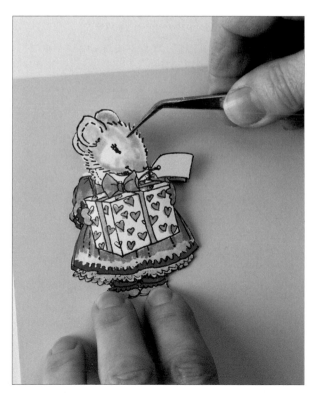

6. Apply three spots of silicone sealant to the back of the image, and a small spot to each foot.

7. Position the mouse on the base print by holding down its feet and lowering the top half into place. The mouse will then look as if it is standing on the floor and not levitating!

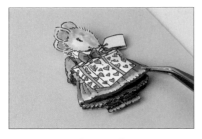

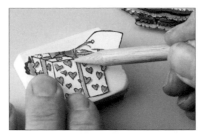

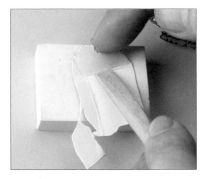

8. Gently shape the pantalettes, the lower half of the mouse's dress, the hem and the collar. Shape only the edges of the dress, not the middle part. Attach each piece to the base print. Tilt the dress towards the head of the mouse as you apply it so that the lower part stands out.

9. Shape the parcel. Rest it on an eraser and score down each edge of the parcel using the pointed shaping tool.

10. Using the flattened end of the shaping tool, bend the sides of the parcel back slightly to give it a three-dimensional shape.

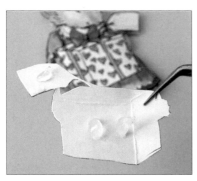

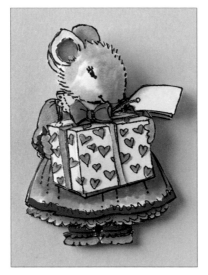

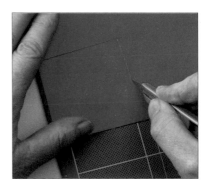

11. Hold the parcel over the base and check that it has not been folded in too far. Add two spots of silicone sealant to the back of the parcel, and one small spot to the label.

12. Attach the parcel to the base, then shape and apply the remaining pieces.

13. Cut out a 60mm (2½in) square of pink card to fit behind the aperture in the card blank.

14. Attach the piece of pink card to the inside of the aperture card using repositionable adhesive dots or double-sided tape. Fold the inside flap over the back of the pink card and glue it in place. Attach the mouse to the front of the card using double-sided tape, and add the red heart craft stickers to the four corners of the aperture.

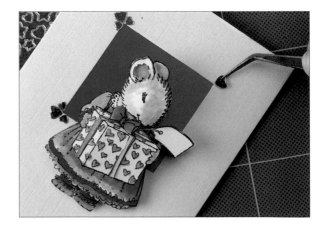

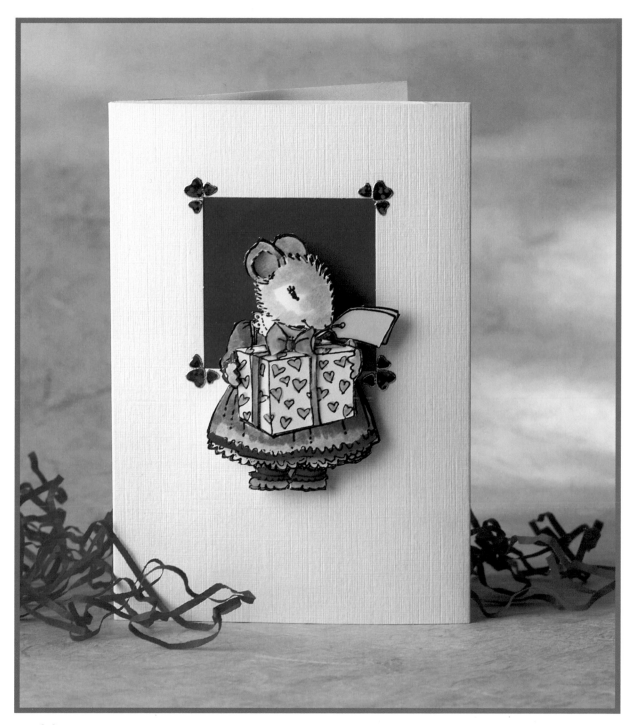

A Gift for You

The finished card shows beautifully how watercolours can be used to create truly individual designs. The darker pink in the mouse's pantalettes and the hem of her dress is highlighted by the pink backing card and the shiny heart-shaped craft stickers. The careful shaping of the parcel accentuates the three-dimensional element of the design and gives the impression that the mouse is lifting the parcel out of the card towards the recipient.

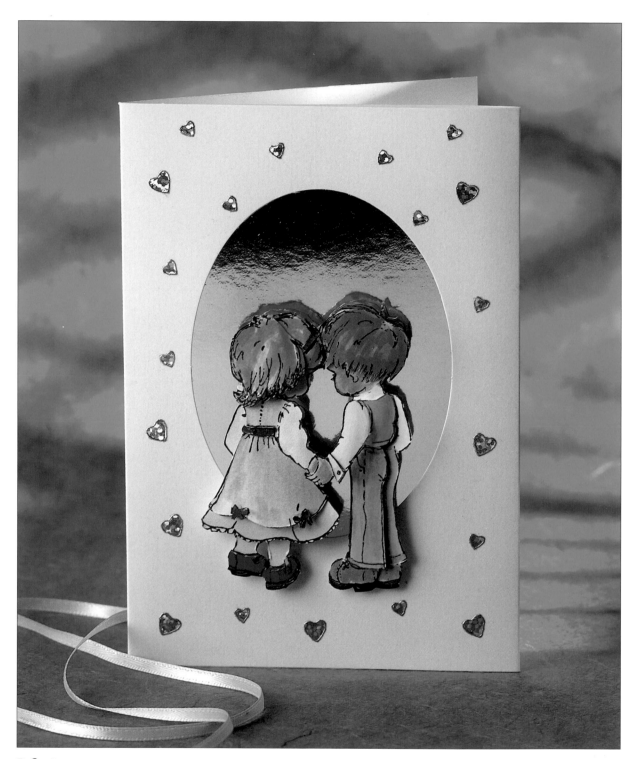

Reflections

By using glossy silver card as a background and colouring in both sides of the two children, a reflection is created that adds an interesting dimension to this very pretty card. The silver holographic hearts enhance the effect, and make it an ideal card for a loved one.

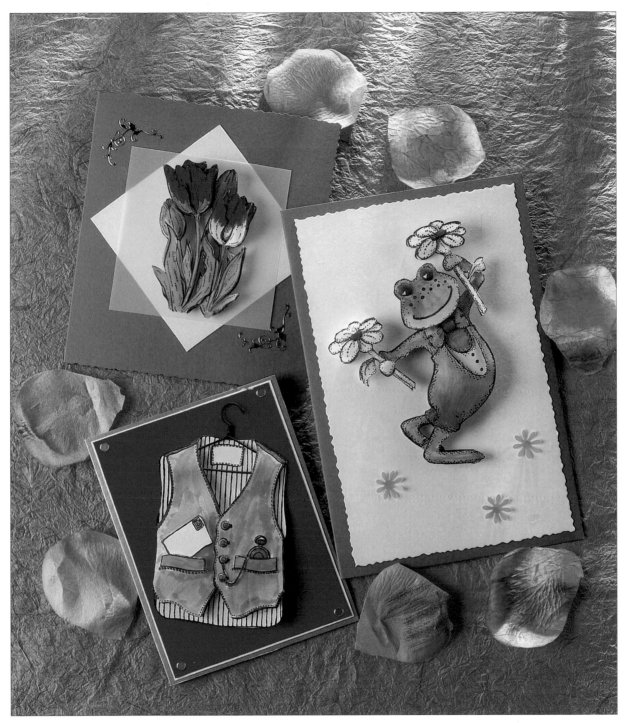

These three cards show how versatile three-dimensional cards can be, and how backing papers and cards can be used to enhance an image.

The strong colours in the top left-hand card are brought to life by mounting the tulips on a light backing of cream card and pale green vellum.

The frog is dancing on a background created by applying yellow ink using a sponge over daisy-shaped outline craft stickers. The daisies are then removed to reveal the white outlines underneath.

Romantic Rose

For the final project in this book I have chosen a gorgeous pink rose – typically associated with love, it makes a perfect card for your loved ones.

The gold outline of the flower is complemented beautifully by its pink petals and green leaves, and I have tried to emphasise the intrinsic beauty of the rose by keeping the design of the finished card simple.

You will need
Gold rose outline craft stickers
Medium-weight A5
white card, 148 x 210mm
(6 x 8¼in)
Cream, linen-effect A5 card
blank, 148 x 210mm
(6 x 8¼in)
Stick-on ribbon
Watercolour pens, blender and
sheet of acetate for
mixing colours
Fancy-edged scissors
Long-handled scissors
Craft knife and spare blades
Shaping tools
Foam pad
Cutting mat
Silicone sealant
Cocktail sticks
Tweezers, straight and angled

1. Using tweezers, peel off four outline craft stickers and lay them on the sheet of white A5 card.

Tip
Don't worry if you colour over the gold outline by mistake – the ink won't adhere to it.

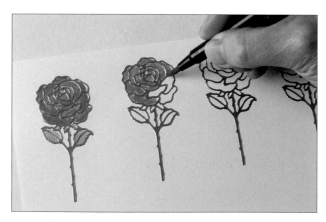

2. Colour in each flower using watercolour pens. Use light and dark shades of pink for the petals, and green for the leaves. Go over a colour two or three times to strengthen it and to create shading effects.

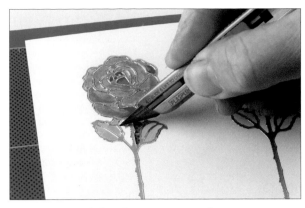 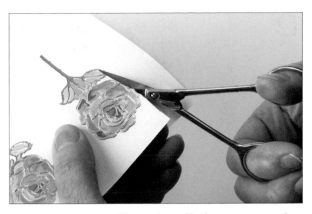

3. Use a craft knife to remove the inner piece of card from two of the flowers.

4. Using a pair of long-handled scissors with a sharp point, cut around the edge of two of the flowers. Make sure you keep outside the gold outline.

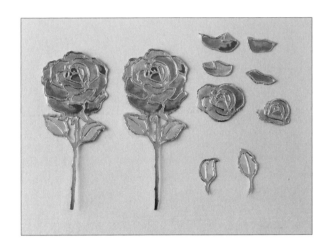

5. Working from the back of the picture towards the front, cut out the parts of the flower you wish to layer from the remaining two images. Cut the bottom petals from the third image, and the top petals and the leaves from the fourth.

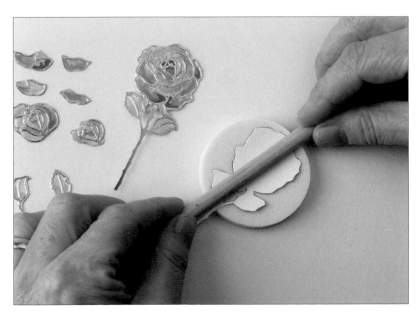

6. Flatten the base print gently with your fingers as thin card can curl up at the edges. Softly shape the second complete flower by resting it on the foam pad and rolling a shaping tool backwards and forwards over it.

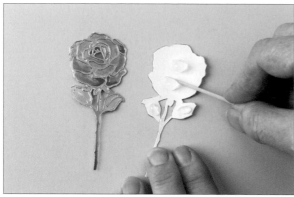

7. Apply a small spot of silicone sealant to each leaf, and two large spots to the centre of the flower, using a cocktail stick.

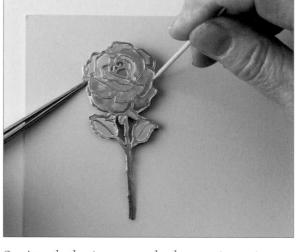

8. Attach the image to the base print using tweezers. Hold the stem down and lower the top part of the flower into position using a cocktail stick.

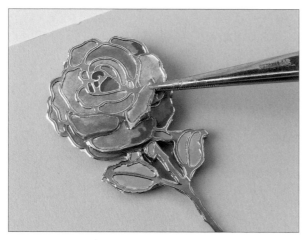

9. Gently shape the bottom petals and attach them to the base. Tilt each petal towards the centre of the flower to produce a three-dimensional effect.

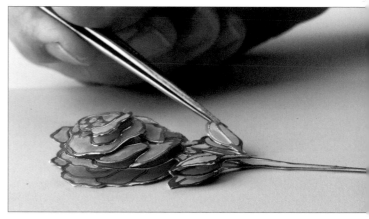

10. Shape the top petals and the leaves and attach them to the base flower, gradually building up the layers from the back of the picture to the front. Shape the petals in the centre of the rose by resting them on an eraser and rubbing them using a circular motion with a spoon-shaped shaping tool. This creates a domed effect and adds to the three-dimensional appearance of the flower.

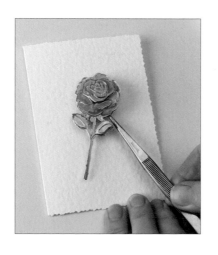

11. Add a decorative edge to the card, and attach the rose at a slight angle using silicone sealant. Embellish the card with a strip of stick-on ribbon.

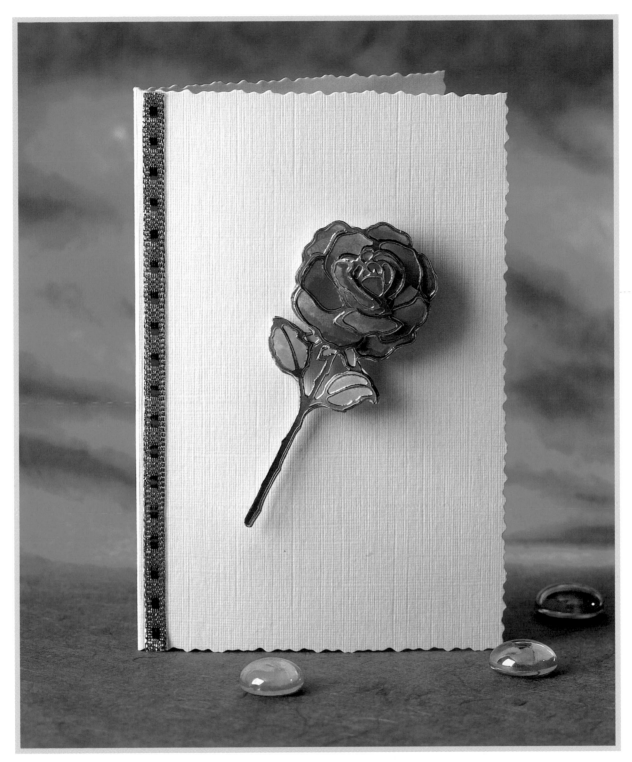

Romantic Rose

The beauty of this single pink rose lies partly in its simplicity. The golden outline serves to enrich the image, so the only embellishment I've chosen is one which enhances this feature – namely a single strip of gold and red ribbon down the left-hand side.

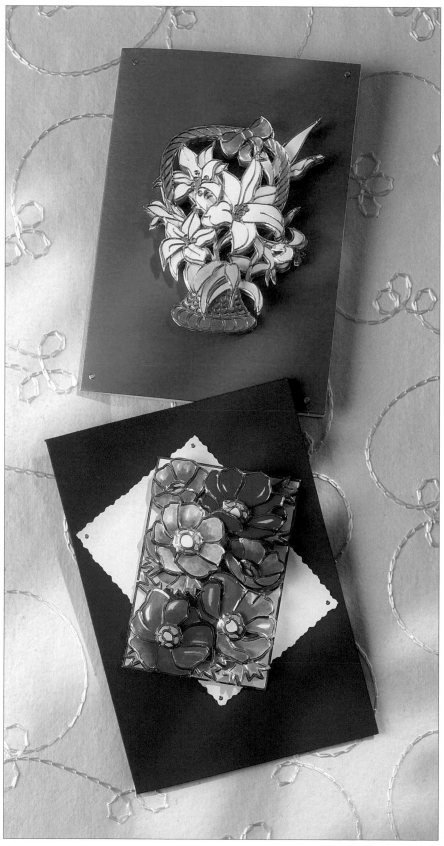

All of the cards on these two pages have been made using gold and silver outline craft stickers. The shiny metallic outlines of the images lend a certain weight to the designs, and can be highlighted by using various gold and silver embellishments.

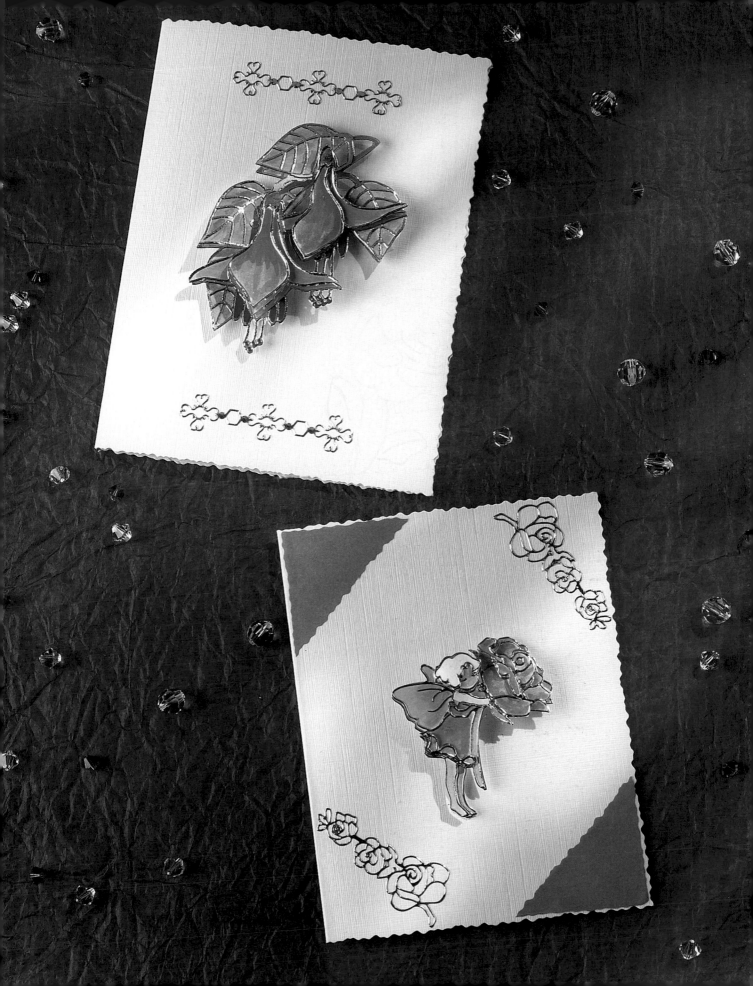

Index